S0-AXK-860

Monet

MICHEL HOOG

Monet

Eyre Methuen

BARRON'S
WOODBURY, NEW YORK

LAYOUT DESIGN BY JACQUES DOPAGNE
TRANSLATION BY DÉSIRÉE MOORHEAD

© FERNAND HAZAN, PARIS 1978

ACHEVÉ D'IMPRIMER EN JUIN 1978
PAR L'IMPRIMERIE JEAN MUSSOT, PARIS

PRINTED IN FRANCE

ISBN 0.413.39870.6

Claude Monet spent his early years in Le Havre and it is tempting to see in this the origins of his fondness for the seascape. Most writers on Monet have been influenced by the theories of Taine which were much in vogue at the end of the 19th century and which attempted to explain a work of art in relation to race, historic period and background. These writers on Monet considered that his youth, spent in Le Havre, had a determining effect on the definition of his art. This observation generally accompanies a list of the many painters of Norman origin or adoption, from Boudin to Lépine and even to the Fauves (Braque, Dufy, Friesz), who painted the sea and its surroundings. The many Norman writers who were contemporaries of Monet are recalled also: Flaubert, Barbey d'Aurevilly, Maupassant. Such a supposition is however meaningless. To pretend that the art of

Monet stems from his youthful days spent by the port means giving way to a form of historic-geographic determinism and to adopt a presupposed theory whose foundation is quite uncertain. It is obvious that Monet, during the course of his youth, watched the sea a great deal as this constituted in itself a mobile, constantly changing spectacle whose contours and lines were strictly speaking of less interest than the variations of shade and value. It is evident that such a constantly revivifying experience may have awakened or stimulated his observations and fed his visual memory and many references to this can be found in his early works. However to the question that his years at Le Havre could really have had a totally determining factor on his work the answer is no, and the history of art is littered by such fictitious theories. In his youth Camille Pissarro spent as much if not more time than Monet by the sea and there is nothing more earthbound than Pissarro's subject. As for that most illustrious of seascape painters, Claude Gellée, he hailed from the Lorraine.

Close in spirit to the works of Eugène Boudin who encouraged the young artist, the scenes of the sea and its surroundings were only a small part of Monet's early production. His first works were clever portraits of well-known personalities of Le Havre executed in the style of caricature. These were the works first noticed by Boudin. The exaggerated facial features and heads posed on gnome-like bodies belonged to the common language of caricature such as that which André Ghil later developed in various satirical newspapers. Occasionally Odilon Redon and

Puvis de Chavannes tried out this form of inquisitive portraiture but for Monet it was simply a way of earning money and although he was only fifteen years old when he made the caricatures he had already mastered a technique of great virtuosity. It however remains a curious fact that while Monet carried out his first works in a fashion which implied a very thorough and systematic analysis of the human face, the greater part of his production bears witness to his vivid dislike of representation of the head. He had strong feelings about this and even in *Women in a Garden, Le Déjeuner sur l'herbe* or in the portrait of *Madame Gaudibert* (that is in three important works painted while he was between twenty-five and thirty years of age) the exact portrayal of the faces, which should be quite natural, is carefully avoided. The painter undertook no further representation of the human face after the 1870 War except in some rare portraits which he made from reasons of affection or friendship.

Thanks to the research of D. Wildenstein the years of Monet's youth are now fairly well documented. For a long time too much attention had been paid to the sayings of the painter himself, and of his close friends, many of which are not quite accurate. Monet was drawn to Paris through the teaching of Ochard, a pupil of David, and by the encouragement he received from Boudin. He worked at the Académie Suisse, then after completing his military service, at the studio of Gleyre met Delacroix, Courbet, Manet and the Barbizon painters, and become the companion of Pissarro, Renoir, Bazille and Sisley. Monet was able to assimilate all these influences of life in Paris and to

weld them into his own personal synthesis. However factors such as the discovery of the light of Algeria encountered during his spell of military service are difficult to discern in his work.

Until in and around 1870 the subject matter of Monet's work remained varied. His still-lives, though few in number, cannot be considered as merely school exercises and if he repeated this subject later on he did not linger long over it. The *Chrysanthemums* in the Jeu de Paume Museum or *Galettes,* of 1889, which is worked in a sharply descending perspective, show the painter's equal ease in the handling of either an object or the reflections of water.

From 1863 Monet often worked in the forest of Fontainebleau after the fashion of Millet and the Barbizon painters who had continued in their particular style for about thirty years. The landscapes he produced, in which the vegetation is a deep and sombre green and the human figure is absent, are not very different in spirit or in technique from the works of either Rousseau or Diaz. At the same time as these landscapes of modest dimensions Monet was working on a much more ambitious composition—his *Déjeuner sur l'herbe.* For the first time he attempted a largescale work (approximately 4.60 m. × 6 m.) but now the painting is only known from a complete sketch in the Pushkin Museum, in Moscow, and from two fragments. The work was a response to Manet's *Déjeuner sur l'herbe* which had recently caused such a scandal and Monet who until that time had painted only small landscapes or minor subjects wished to prove to himself and to the public that in a composition featuring several

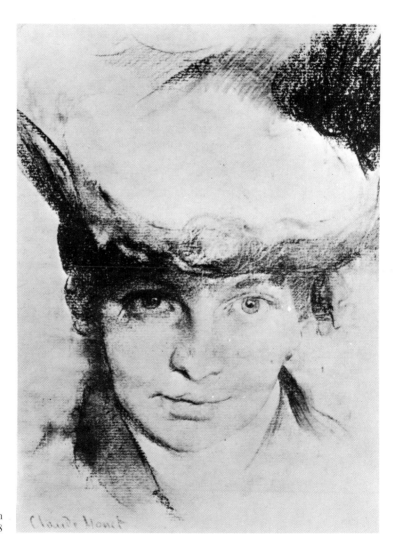

Head of a Woman
ca 1868

figures he was capable of mastering such a huge and complex organisation. The layout is relatively tame and the subject is of a non-shocking modernism closer to the scenes of hunting parties of Alfred de Dreux which stemmed rather from the 18th century tradition (De Troy) than from the deliberate provocation of Manet and Courbet. The novelty of Monet's treatment of the work was not in the subject matter but in the handling of the light and shade which assume a definite contrast from his models.

On a similar theme, *Women in a Garden* (1866-1867) in the Jeu de Paume Museum, allows this contrast to be more clearly observed. In spite of the difficulties of handling a canvas of this size (2.56 m. × 2.08 m.) Monet determined to work the painting outdoors, in the open air. The composition is knowingly asymmetric and there is no longer the serene balance of elements found in *Le Déjeuner sur l'herbe*. The light and dark masses are cleverly organised and above all the play of reflections, transparencies and shadows on the dresses and faces of the models is handled in a way no other painter had previously attempted.

The *Terrace at Saint-Adresse* (1867, Metropolitan Museum, New York) is another example of a carefully constructed painting. Monet had already been the target of harsh criticism and in this work it seems that he seeks to reassure. However, the straightforward, sunlit poetry with its striking colour, luminous shadows and absence of narrative shows the artist to be making a break with the standard conventions. Monet executed many landscapes

and portraits, in varying styles, both in Normandy and in Paris and its surroundings. Here it should be noted that Monet began his career by trying out several differing styles while in later years he was to concentrate on the painting of almost similar scenes, of similar dimensions, in the open air. It is true that some of the peculiarities which would become increasingly noticeable were already apparent but Monet had not yet given up certain of his researches and he continued his experiments for many more years.

During the 1870 War Monet spent some time in London and in Holland. He was interested in the work of the English School particularly in that of Constable and Turner whose paintings he viewed in the company of Pissarro. Turner showed him how it was possible to go much further in the analysis of atmospheric phenomena than had been previously attempted but Monet never tried for the particular dramatic effects so dear to Turner.

Actually the journey did not produce a definite change in Monet's work which was slowly reaching maturity and the paintings which provoked the scandal of Impressionism from 1874 onward were not experiments but the results of the work of an artist who had already undertaken ten years of personal research. Monet, Cézanne, Degas, Berthe, Morisot, Pissarro, Renoir, Sisley and others who worked with them were constantly refused admission to the official Salon by juries hostile to innovation. Thus in 1874, eager to affirm their communal creative spirit, these artists set up a limited company with a view to organising an exhibition of their own work. To-

day we are accustomed to the existence of a multitude of Salons and exhibitions of all tendencies but in 1874 the idea of a group of young artists banding together to show their own work was a courageous and daring initiative. The exhibition was held in the studio of the photographer Nadar, on the boulevard des Capucines, and became a great success partly through scandal and partly through interest. Claude Monet was the chief target of the critics who some years previously had pretended to confuse him with Manet and it was one of his paintings, *Impression, Sunrise,* which was adopted as the label of the group.

Now in the Marmottan Museum in Paris the painting (its identification is more or less certain) shows the port of Le Havre enshrouded in mist in the early morning. The study of the diffusion of light through mist and its play on the surface of the water becomes of paramount importance and supersedes the actual drawing and composition. Such a painting which systematically and wilfully opposed the admitted conventions could only shock and the new word, impression, helped to arouse the ire and misunderstanding of the critics and furnished them with a derisive title for the group. The painters themselves adopted this term which Monet had probably employed originally to diminish the importance of the painting which he presumed to be merely the result of a momentary perception and not a highly elaborated work. In the end *Impression, Sunrise,* is not altogether characteristic of the technique of either Monet or his friends who in reality paid a great deal of attention to the construction of a work.

The paintings of this period seek to convey a quick glimpse of the passing parade. Monet's favourite subjects were people strolling on the Paris boulevards, reflections on the Seine or on the waters of a harbour, a sunlit flower-strewn meadow or a field covered in snow. His preference for the changing as opposed to the static scene is clear as is his analysis and rendering of the phenomena of light which he prefers as opposed to concentration on structure and texture. *Impression Sunrise,* is the culmination of Monet's research in this direction but is probably not the most characteristic result which is rather to be observed in the scenes of Argenteuil, a locality near Paris on the banks of the Seine, where Monet worked frequently.

The scenes of Argenteuil have been widely reproduced and are very well-known. Their subject is familiar: a group of pleasure boats, the arch of a bridge, trees by the bank reflected in the water, but the human figure is generally reduced to a mere silhouette. Such are the components of some of Monet's most famous paintings which have taken their place in the history of art. Along with certain Renoirs of the same period these are some of the rare works of art which achieved recognition also by the public (or, as is said, a non-public) generally indifferent to art but who found a spiritual relationship in the works of the Impressionnists. This is a rare occurence.

Monet and the Impressionists were accused of banality, of lacking inspiration, of simply being interested in nature or insipid reality which they rendered in an unexciting and unimaginative fashion. Their theme of everyday life varied little and could explain the reaction of Gauguin's

exotic escapades, Cézanne's préoccupation with the timeless and monumental and Redon's inner dream. The Impressionists painted the Parisians at leisure but it would be unjust to refuse a poetic dimension to their work. They loved the nearness and reassuring familiarity of nature and modern subjects. In the paintings of the *Gare Saint-Lazare* the railway engine is wrapped in a veil of luminous mist which lends a sort of nobility to this mechanical subject and it is all of thirty years before either Delaunay or the Italian Futurists glorified the machine in their work. The depiction of a smoking engine furnished another pretext to render an object with no definite contours and which is only described by the light which streams through it. That Monet knew very well how to accomplish his own formulas can be seen in other works of which there are few but important examples such as *Camille in Japanese costume* (1876, Boston) or *Turkeys* (1877, Jeu de Paume Museum).

It is difficult to realise the violence of the reaction against Monet and his friends and the scandal their work provoked. In spite of Corot and the Barbizon painters the public at that time admired the type of painting which told a story or illustrated an event. The works of the Impressionists dismayed by their apparent insignificance and by the very virtues which please us at the present time, their charm and their familiarity. They are not descriptive works and were intended to be looked at rather than talked about which is perhaps the reason for their present fall from grace in the eyes of certain critics who have been influenced by the figurative trends of today.

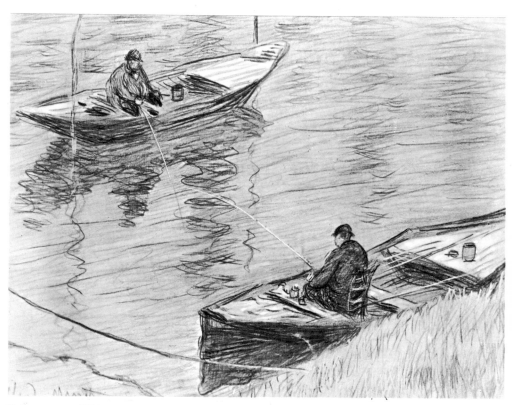

Fishermen. *ca* 1880

The work of Monet, Sisley, Pissarro and Renoir brought about a profound change in the vocabulary of painterly tradition. They knew that the tone which appears on a given surface depends less on the colour of the pigment than on the light which illuminates it and the colours of the surrounding objects. They analysed the smallest detail of a reflection and made use of subjects suitable to such an analysis such as water, mist, snow or smoke. They made a play of the complementary colours avoiding the use of grey and brown and contrary to what has been written they made little use of optical mixes of divided colour directly on the canvas but rather prepared their colour on the palette.

Monet was generally acknowledged to be the leader of the Impressionist movement but he was one of six or seven painters linked by friendship and a communal pursuit of similar research. They worked closely together exchanging ideas. They profited from the pioneering experiences of Delacroix and Manet but at the same time they were quite aware of the revolutionary nature of their art. The stories which grew up around Monet and Renoir towards the end of their lives in conversation with Ambroise Vollard and Gustave Geffroy are probably best taken with a pinch of salt. The two pretended to be instinctive, almost self-taught artists who had brought about the revolution of Impressionism in a natural, easy manner thanks to their pure, innocent vision. It is true that they were little given to theorising or argument but their early works are not at all ingenious. They are, on the contrary, extremely sophisticated and well organised. Monet, as

happened with many others, liberated himself from traditional artistic formation and sought a new way of working which demanded years of research and it would be quite ridiculous to believe that this research did not involve exchanges of ideas and theory amongst his friends.

Between 1880 and 1885 the Impressionist group underwent a certain radical change occasioned by the onset of age, fame and the material ease which succeeded years of poverty. The group broke up physically as they gradually became aware that the development of Impressionist principles led to a certain sclerosis. The use of the word principle may seem a·trifle pompous and not suitable in the context but the Impressionist movement has been done an injustice when described as the spontaneous result of the work of a group of young and ingenuous artists when in reality it was the outcome of ten years of serious work. .

From 1880 Renoir attempted a more austere way of work enclosing form by a precise line and using more pungent colour. Pissarro was tempted by the research of the Neo-Impressionists and Cézanne, Gauguin and Van Gogh used their knowledge of Impressionism to further their own individual quest. Monet's work did not undergo an important change until around 1886-1888. He left Vétheuil, remarried Blanche Hoschedé and began to enjoy a certain fame.

Ladies with a Parasol (1886) and the large paintings showing boats on the Epte (1887) are the most characteristic examples of Monet's new research. The format used was of larger scale than the work of the previous ten years and it

is evident that these were of great importance to the painter. Except in one instance where the boat is empty all of the paintings show figures in full scale situated in natural surroundings. That the models were Monet's step-daughters is significant as until then, and apart from the odd portrait, the human figure had been reduced to a mere silhouette. The two versions of *Lady with a Parasol* (Jeu de Paume Museum) are a systematic exercise in Impressionism as is seen in the play of coloured shadows on the face and dress. The Boats sequence shows a precise, sometimes rigid construction, which is in strong contrast with the paintings of previous years in which the break-up of form was heavily accentuated. Monet may have seen paintings on the same theme by Caillebotte or it could be that in his insistence on the play of the diagonals and the flattened perspective he was paying hommage to the newly awakened interest in Japanese art. This shift to a more rigid formalism was in keeping with the times whatever be its cause or consequence. It was not just coincidence that these well planned paintings are almost contemporary with Seurat's *Grande Jatte* and *Parade,* with Gauguin's *Vision after the Sermon* (1888) and the most impressive of Cezanne's series of the *Sainte-Victoire Mountain.* The works have in common their monumental and grandiose construction.

Soon after this Monet began work on his series. He had previously made paintings of the same subject as was the case in 1877 with his studies of the *Gare Saint-Lazare* of which there are five or six fairly different versions. In the *Poplars* series he still allows for a certain diversity within a

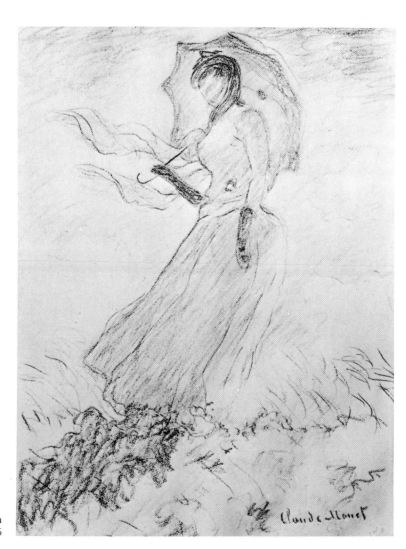

Lady with
a Parasol. 1886

similar subject but it is with *Haystacks* (1891) and the *Rouen Cathedrals* (1894) that the process becomes a systematic one and extends over a sequence of about thirty paintings. When he painted *Haystacks* Monet set up his canvasses in the actual hayfield and worked on several at the same time transferring from one to the other with the passage of the sun. The works are similar but not absolutely identical. Their diversity lies in the differing values of hue as Monet attempted to render light at different hours of the day and different seasons.

The series were exhibited from 1891 onwards and were much admired by the painter's Impressionist friends but they did not altogether disarm the critics. And, from Derain to Matisse, from Delaunay to Liechenstein and Malevitch such series would continue strongly to interest many artists. This departure was of tremendous interest and made an especially strong impression on Kandinsky, whose origins as a painter started with his admiration of the *Haystack* series. He himself from 1910 undertook work in series, one of which he entitled *Impression*.

Monet went to Norway (1895) and to London (1900-1903) and he visited Venice for the first time in 1908. At the same time he began to paint the ornamental pond which he had installed in his garden at Giverny and from which would stem the *Water-lilies*. This theme absorbed the greather part of his activities during his last twenty years when he was regarded as a high-priest of art. He could be a little grouchy but he enjoyed the visits of deferential young artists and art lovers from France and elsewhere.

In the first versions of the *Water-lilies,* those of square or circular format, the little bridge and the willows which act as a focal point are still readable but little by little the perspective is sacrificed and the mass of greenery constitutes a continuous, overlaying decor. In all there are about 250 paintings on this subject and the early ones were exhibited in Paris in 1900. Monet had a special studio built in 1912 and in 1914 he began work on eight very large compositions which thanks to his old friend, Clemenceau, were donated to the French State and installed in the Orangerie Museum under Monet's directions. Even today these works have lost nothing of their revolutionary force. Monet had broken with the old habit of painting on a canvas propped on a easel and the result was not that of a fresco but rather the creation of an environment where the spectator is immersed in a timeless, multi-coloured atmosphere. There is one subject, a wall of greenery and water, and no longer is there conventional composition, drawing or outline.

Monet and his cronies, Clemenceau and Gustave Geffroy, were heavily insistant on what they referred to as the realist character of the *Water-lilies.* As they saw it Monet was the meticulous interpretor of the changing atmospherics playing at all hours and seasons on his stretch of water. Today we respond more to their unreal and visionary character with the evocation of a lush, timeless nature in which man can wander as in an all enveloping biosphere. Clemenceau was little given to this type of interpretation but seems to suggest it when he remarked about one of the Orangerie panels: "the sun sets in the

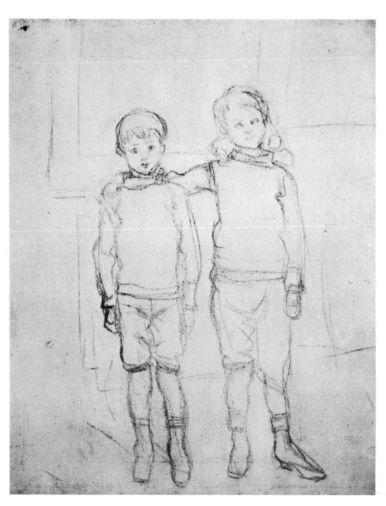

Michel Monet and
Jean-Pierre Hoschedé
ca 1885

reed beds from where the bewitching flowers of spring will appear giving way to unplumbed depths of eternal renewal". He speaks elsewhere of "the drama of the *Water-lilies* on the stage of an eternal world".

Together with this cosmic interpretation the *Water-lilies* have been compared to the advent of tachisme and action painting and it is possible that Tobey and Pollock were influenced by the work. They too refused the constraints of the easel and of organised composition and their painting has the same total liberty and intricate linear construction as Monet. The latter was contemporary to the beginnings of abstraction (1912) and it is a logical follow-up from his exclusion of narrative in his subjects that his work would often be a starting point for abstract artists. It is not generally known if he saw any works of abstract art but he would surely have been informed of the progress of younger painters and without any doubt he had concluded from his resarches of over forty years that painting had gone beyond the depiction of realism. He did insist that his work depended on the observation of nature in order to defend himself from critics but this could also have been a throw-back to the atmosphere of his youth when realism was paramount. For this reason perhaps he could not concede that in *Water-lilies* the relationship with reality has either disappeared or been transposed. To create an alibi he took great pains to arrange his garden to resemble that which he wished to paint. Once again it was a case of nature imitating art.

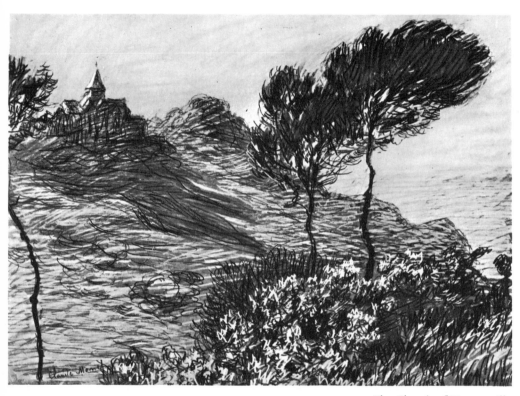

The Church of Varengeville

Biography

1840
Claude Monet is born on 14th November, in Paris.

1845
The Monet family leaves Paris for Le Havre.

1859
Paris. Monet works at the Académie Suisse, where he meets Pissarro.

1862-1863
Monet enters Gleyre's Academy and works with Bazille, Renoir and Sisley.

1863-1864
He works with Bazille at Chailly-en-Bière, near Fontainebleau, and at Honfleur.

1865
Two paintings by Monet are accepted by the Salon. He starts work on his *Déjeuner sur l'herbe*.

1867-1869
Monet lives partly in Normandy and partly in the Paris region (Ville-d'Avray, Bougival). He works with Renoir. Meetings at the Café Guerbois.

1870
Monet marries Camille Doncieux. Visits London with Pissarro where he meets the dealer, Durand-Ruel, who was to be his most consistent collector for many years. First trip to Holland.

1871
Moves to Argenteuil.

1874
Second trip to Holland. First Impressionist exhibition in Paris. Monet considered leader of the movement.

1878
Vétheuil.

1879
His wife dies.

1880
First one-man exhibition at *La Vie Moderne*.

1881-1882
Normandy: Fécamp, Dieppe, Pourville, Varengeville. Monet moves to Giverny.

1884-1889
Visits to Bordighiera, Etretat, Belle-Isle, Antibes, Fresselines (Creuse).

1892
Monet marries Alice Hoschedé.

1890-1893
The first series: *Haystacks, Poplars,* the *Rouen Cathedrals.*

1894
Visits Norway.

1899
First of the *Water-lilies* sequence.

1904
London.

1908
Venice. Monet has problems with his eyesight.

1911
Death of his second wife.

1921
Large *Water-lilies* donated to French State.

1926
5th December, Monet dies at Giverny.

List of plates

70 Water-lilies, Waterscape. 1905.
Boston, Museum of Fine Arts.

71 Water-lilies, ca 1916-1922.
Zurich, Mrs. C. Buhrle collection.

72 Venice. The Grand Canal. 1908.
Boston, Museum of Fine Arts.

73 Water-lilies, Waterscape (detail). 1906.
Paris, private collection.

74 Water-lilies, 1907.
Saint-Etienne, Musée d'Art et
d'Industrie.

75 Water-lilies, ca 1918-1921.
Paris, Musée Marmottan.

76 Water-lilies, Waterscape. 1908.
Zurich, private collection.

77 Water-lilies, Waterscape (detail). 1904.
Le Havre, Musée des Beaux-Arts.

78 Water-lilies, Waterscape (detail). 1908.
Private collection.

79 Water-lilies (Pink Clouds). 1916-1923.
Paris, private collection.

80 Water-lily Pond, Giverny. 1919.
Paris, private collection.

81 Weeping Willow. ca 1919.
Paris, Musée Marmottan.

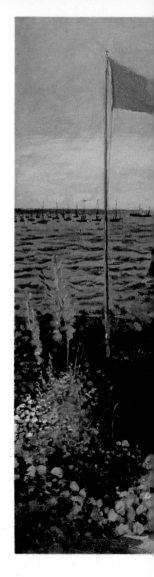

1
Terrasse à Sainte-Adresse
ca 1866-1867

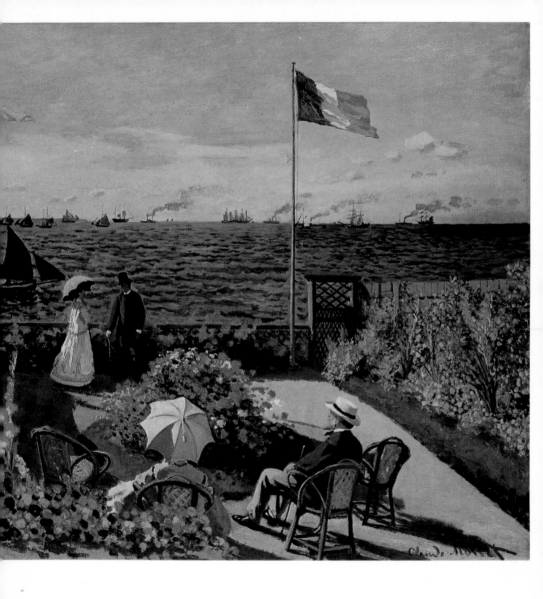

La Charrette, route sous la neige à Honfleur
1865
The Cart, Road under Snow at Honfleur

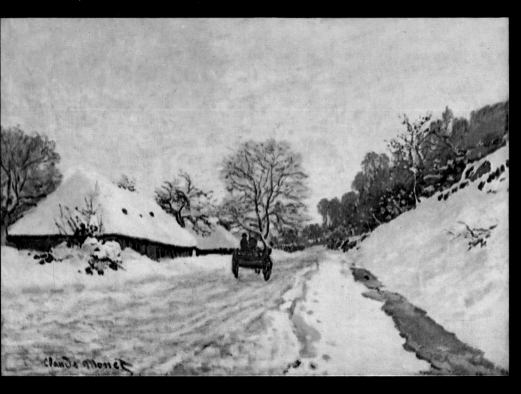

Claude Monet

La Pie
ca 1870
The Magpie

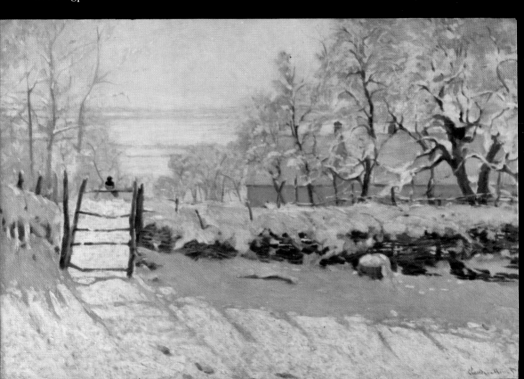

4 et 5
Femmes au jardin
1867
Women in the Garden

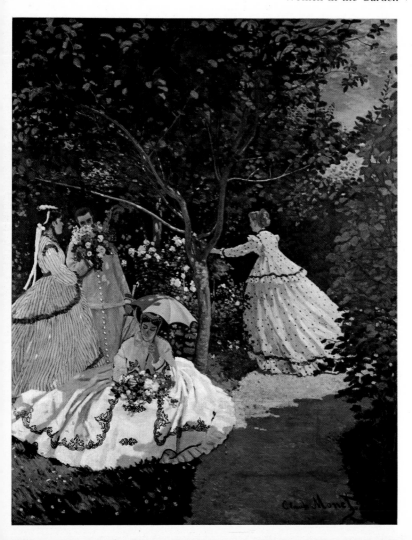

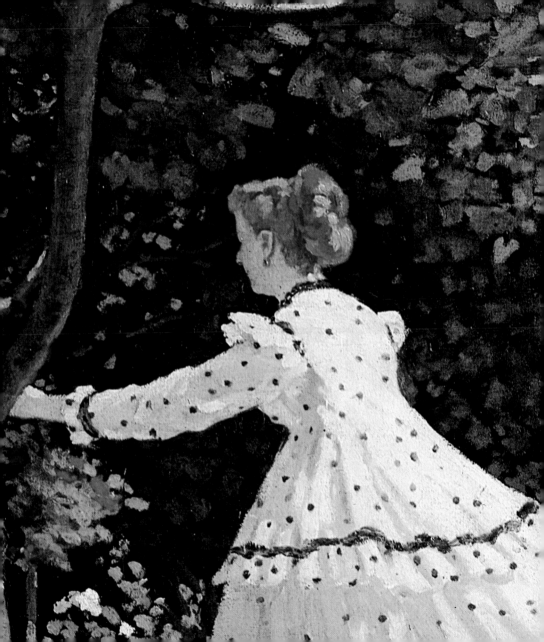

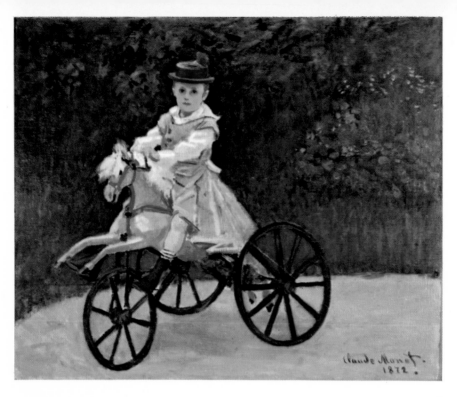

6
Jean sur son cheval de bois
1872
Jean Monet on his Wooden Horse

7
Mme Gaudibert
1868

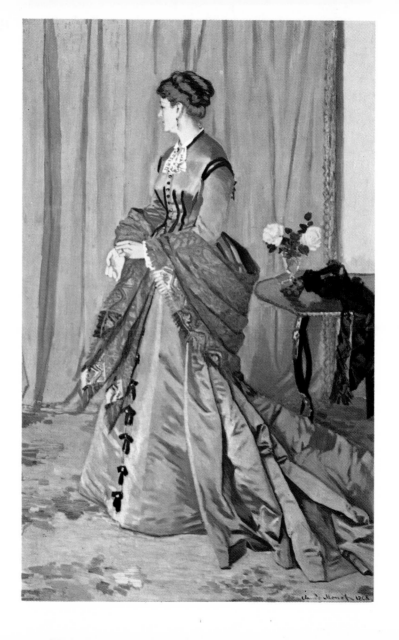

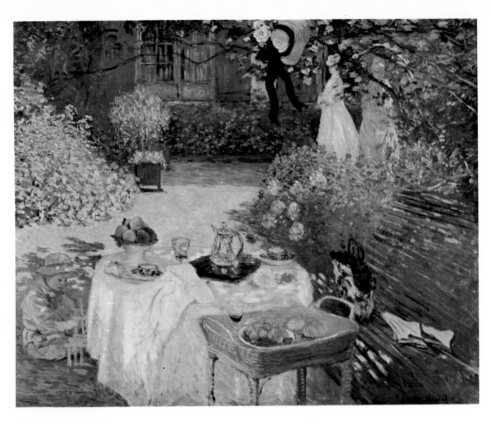

8
Le Déjeuner
ca 1872-1874
The Breakfast

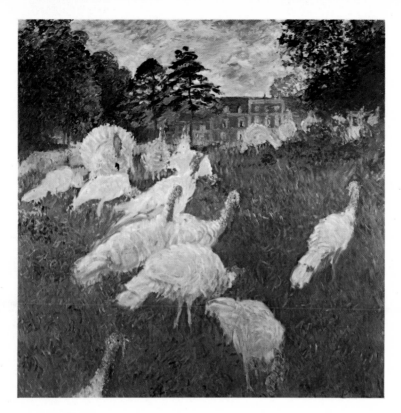

9
Les Dindons
1877
Turkeys

10
La Grenouillère. 1869

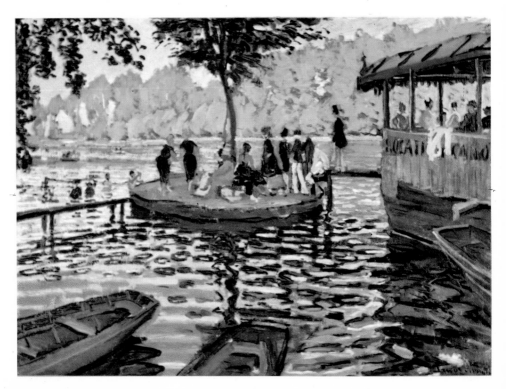

11

Les Déchargeurs de charbon.　1872.　Unloading Coal

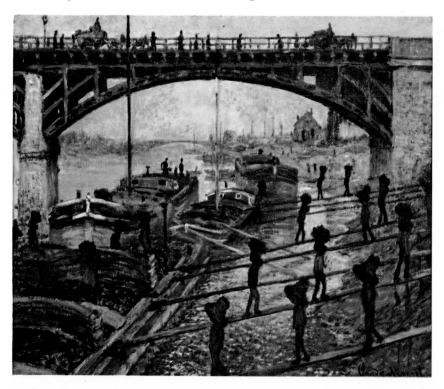

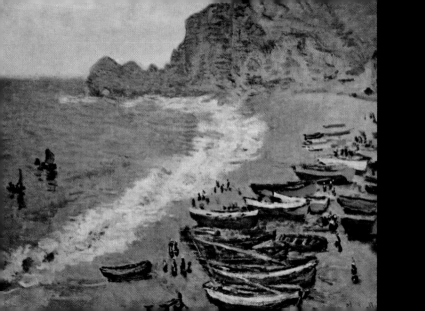

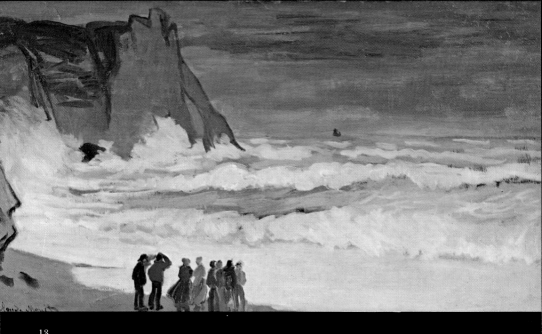

13
Grosse Mer à Etretat. *ca* 1868. Rough Sea at Etretat

14
La Cabane du douanier, Varengeville
1882
The Coastguard's Hut, Varengeville

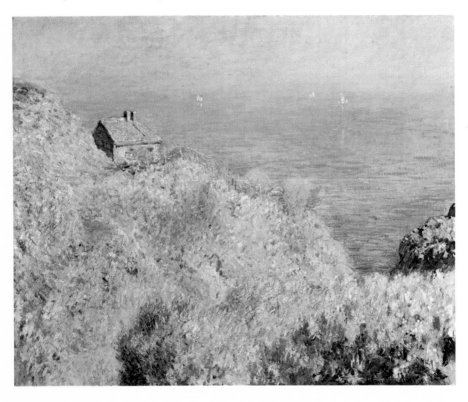

15
Falaise à Etretat (la porte d'Aval)
1883
Cliff at Etretat (la porte d'Aval)

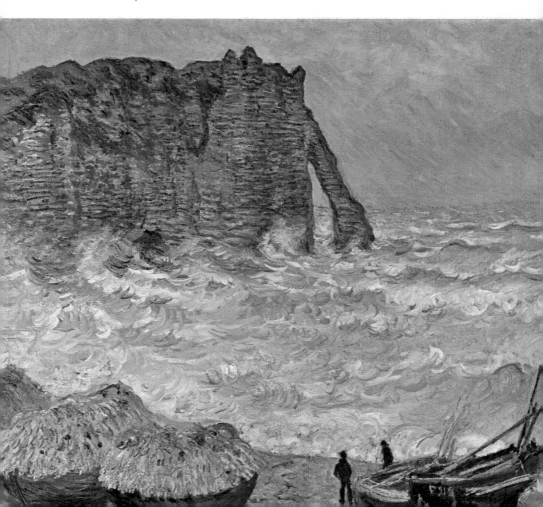

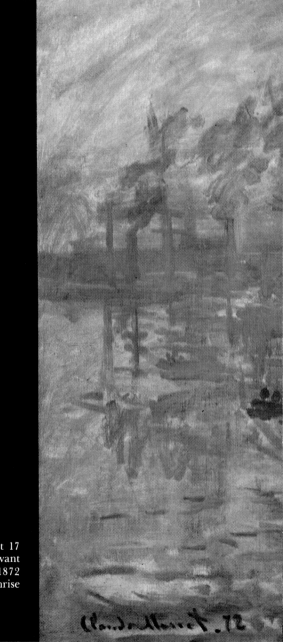

16 et 17
Impression, soleil levant
1872
Impression, Sunrise

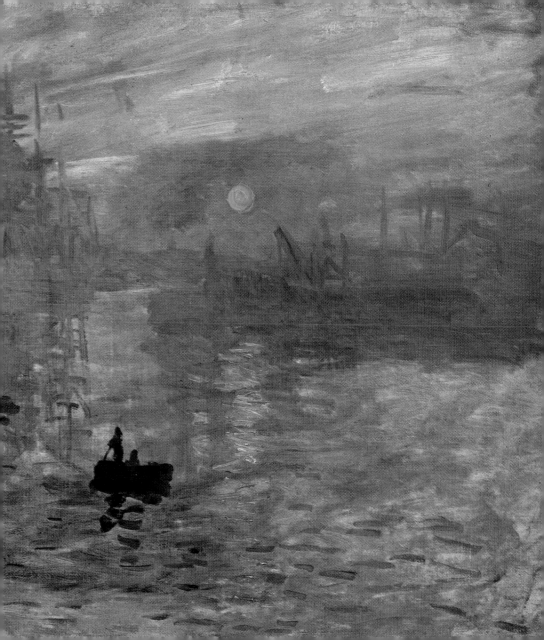

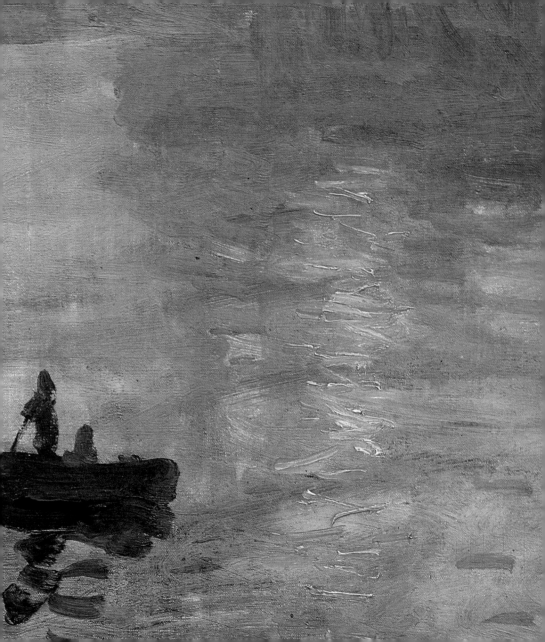

18
Le Repos sous les lilas
ca 1873
Rest under the Lilacs

19
Parisiens au parc Monceau
1878
Parisians at the Parc Monceau

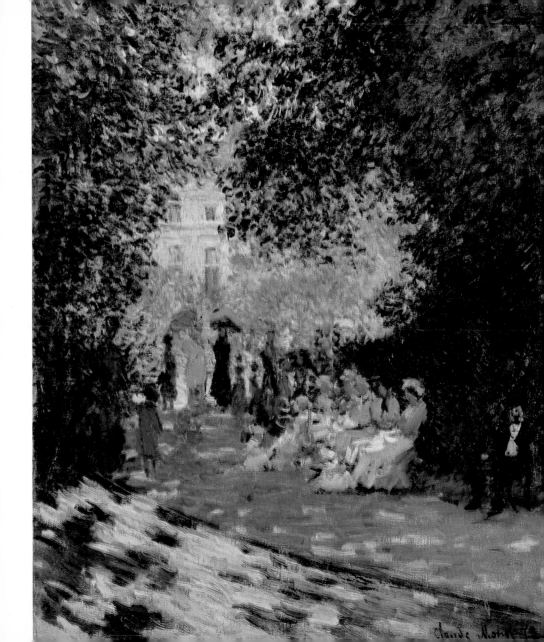

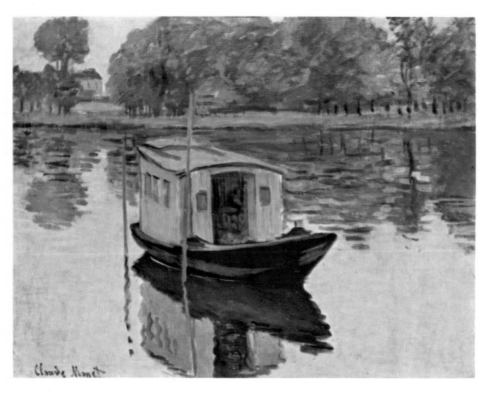

20
Le Bateau-Atelier
1874
The Studio Boat

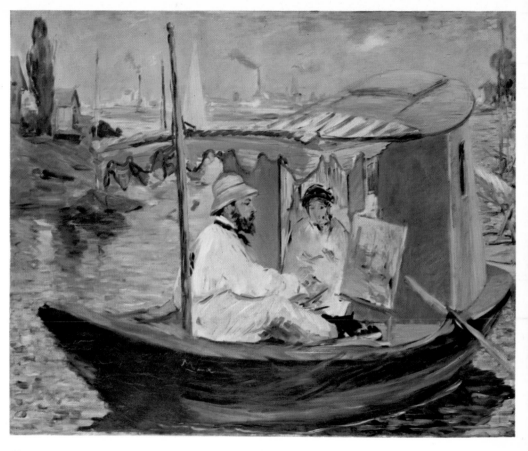

21
Manet. Claude Monet peignant sur son bateau
1874
Manet. Claude Monet painting on his Boat

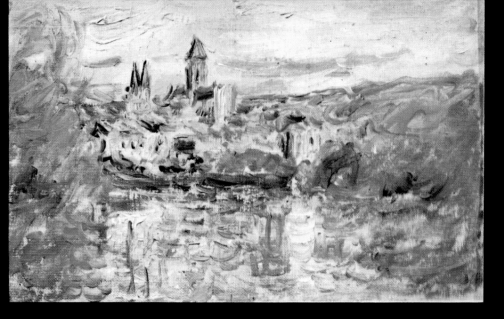

22
Le Village de Vétheuil
1879

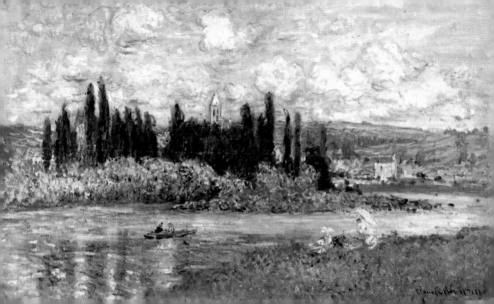

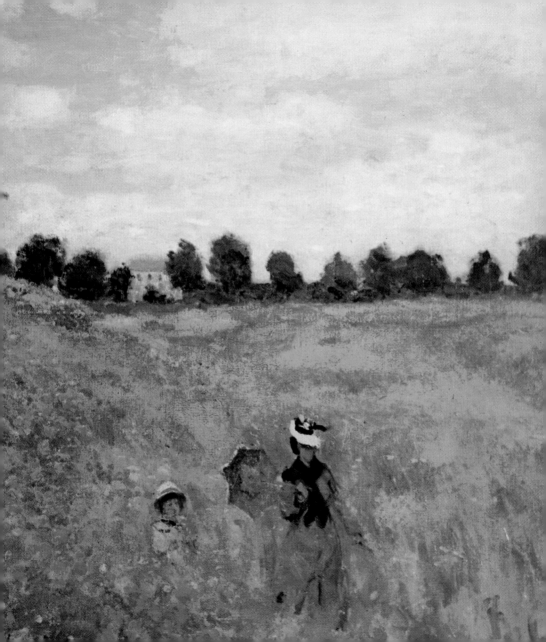

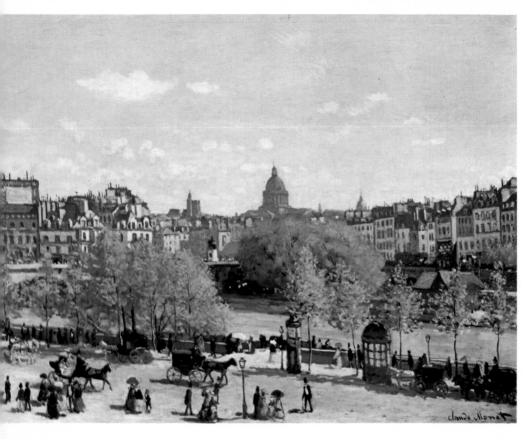

25
La Seine et la montagne Sainte-Geneviève
vues du Louvre
1886
View of the Seine from the Louvre

26
Boulevard des Capucines
(détail)
1873

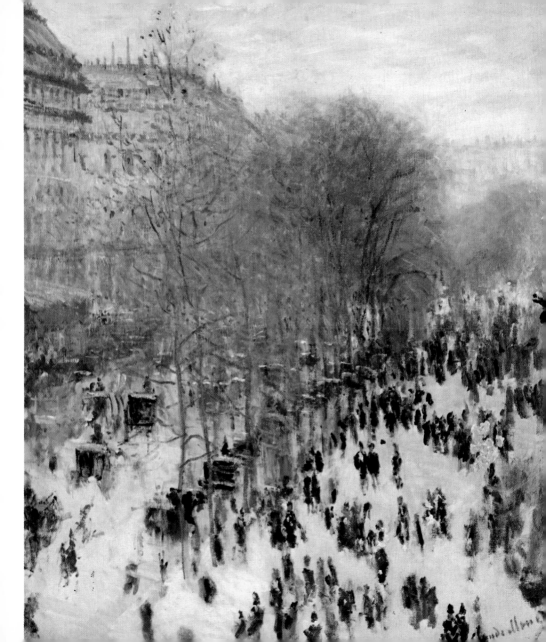

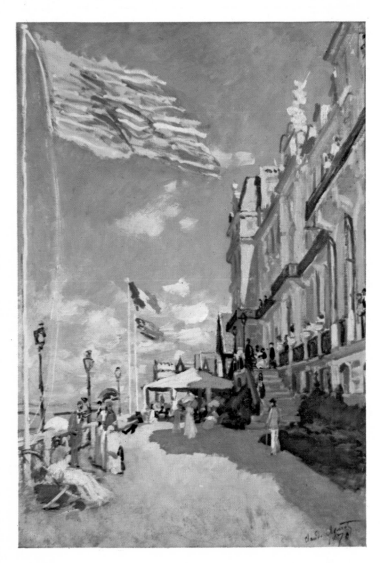

27
L'Hôtel des Roches noires,
à Trouville
1870

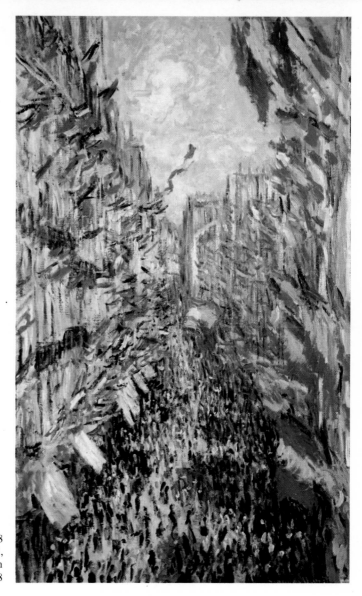

28
La Rue Montorgueil,
fête du 30 juin
1878

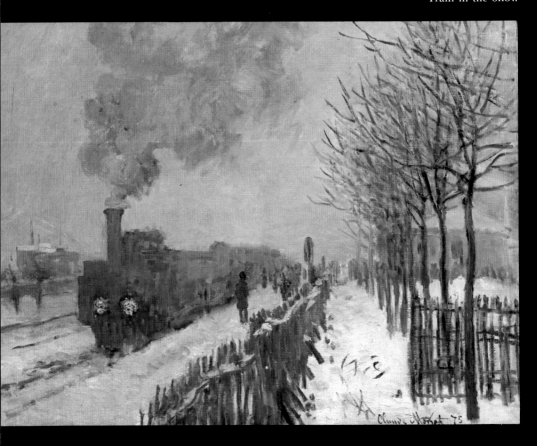

Le Train dans la neige
1875
Train in the Snow

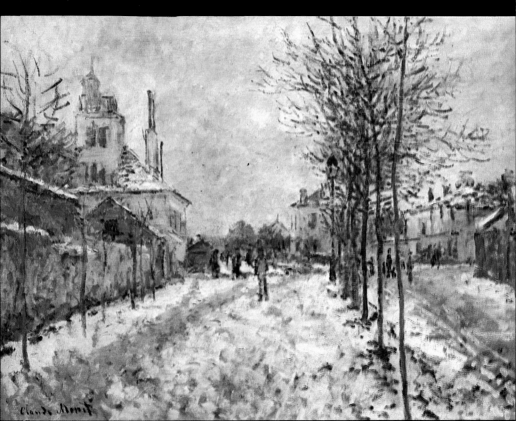

31
Régates à
Argenteuil
ca 1872
Regatta at
Argenteuil

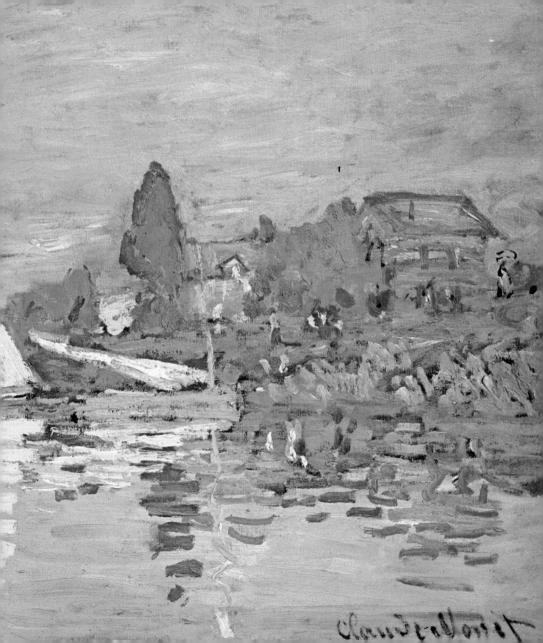

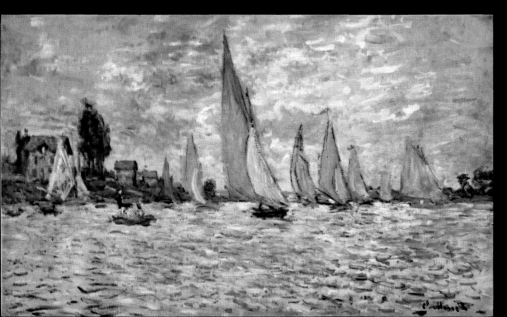

Voilier à Argenteuil
ca 1874
Sailing-boat at Argenteuil

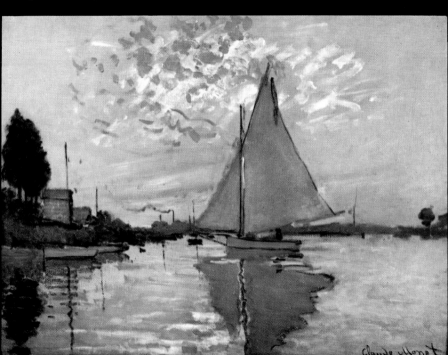

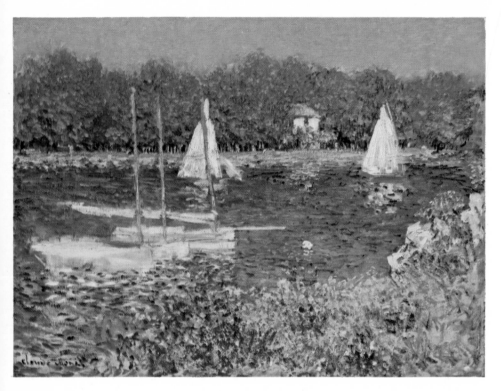

34
Le Bassin d'Argenteuil
1874

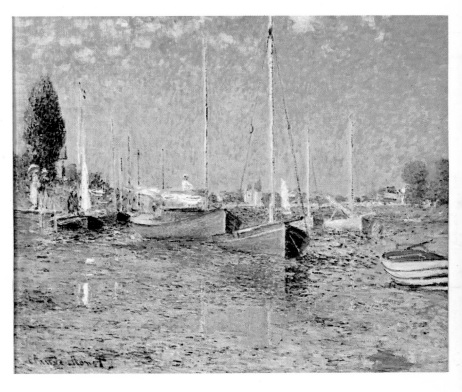

35
Argenteuil
ca 1875

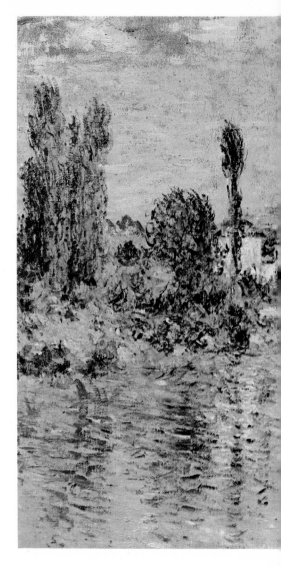

36
Vétheuil
1880

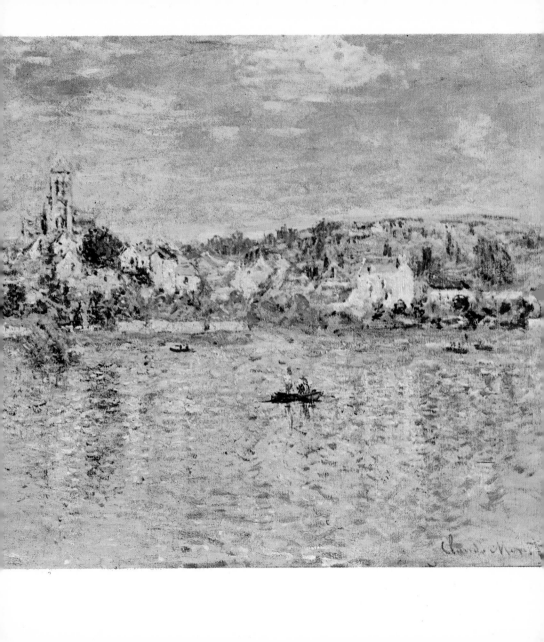

37
Le Pont de l'Europe. 1877

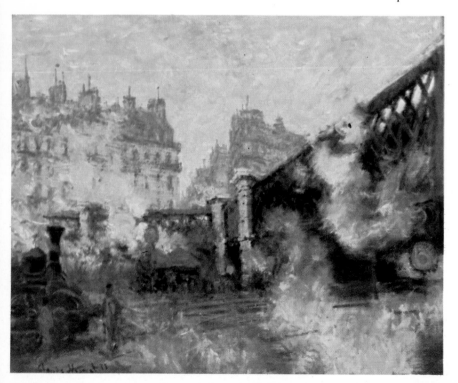

38
La Gare Saint-Lazare. 1877

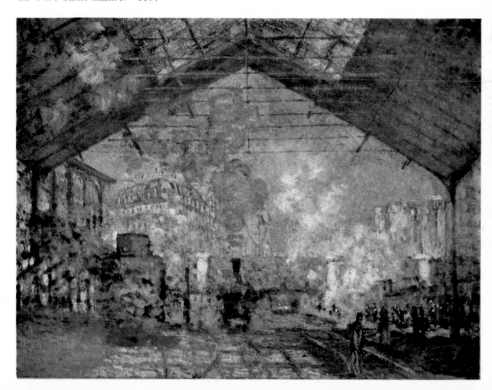

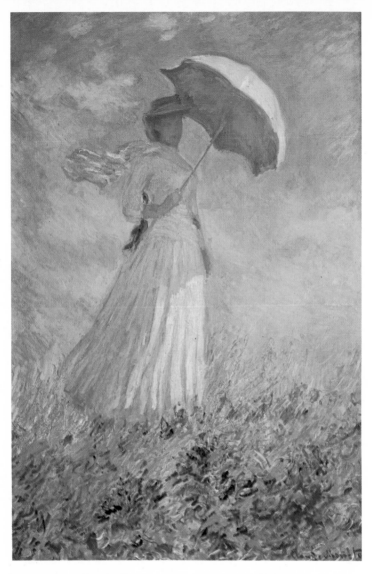

39 Femme à l'ombrelle, tournée vers la droite. 1886
Lady with a Parasol, turned towards the Right

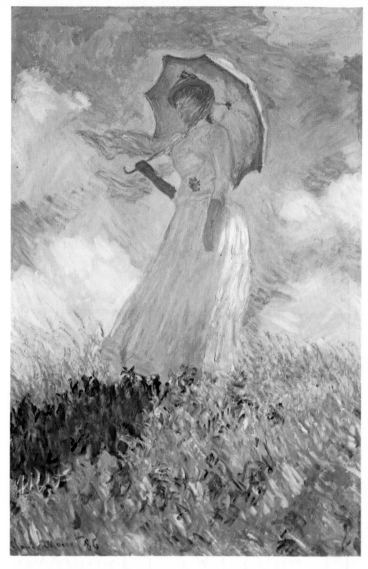

40 Femme à l'ombrellé, tournée vers la gauche. 1886
Lady with a Parasol, turned towards the Left

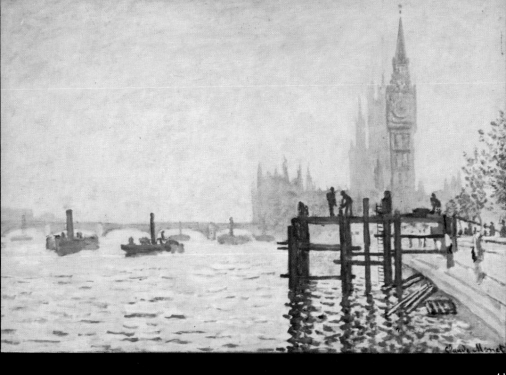

Le Pont de Westminster
1871
Westminster Bridge

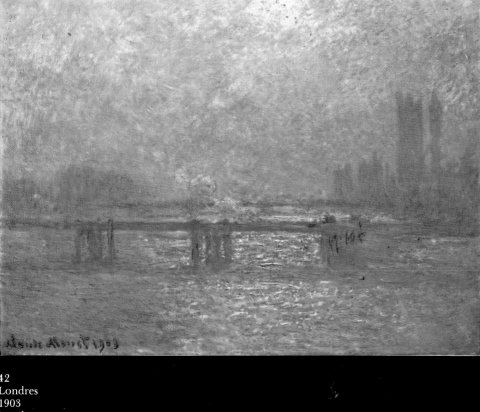

42
Londres
1903
London

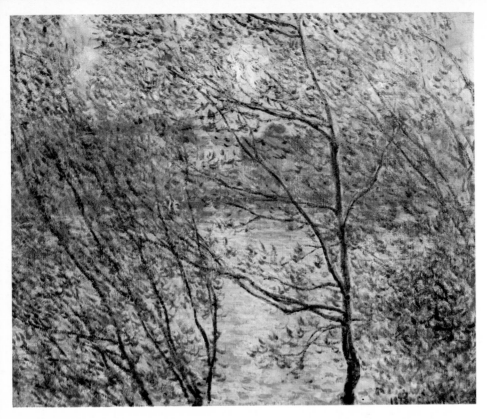

43
Les Bords de la Seine. Le printemps à travers les branches
1878
The Banks of the Seine. Spring through the Trees

44
Madame Monet assise sous un saule
1880
Madame Monet under the Willows

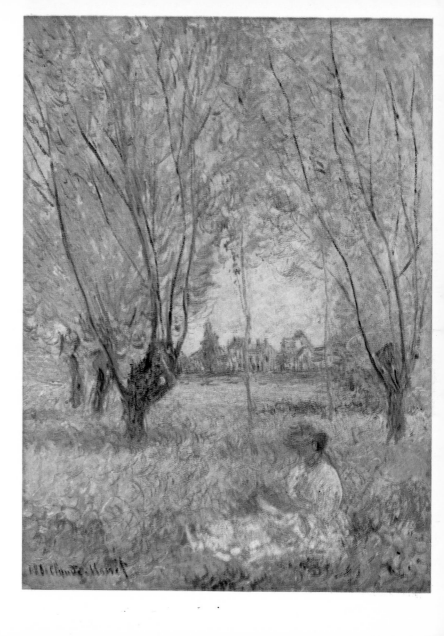

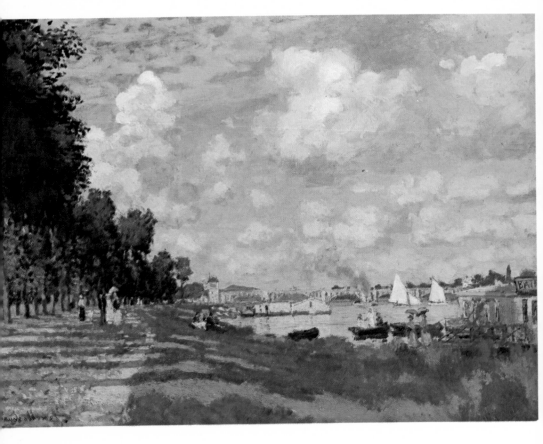

45
Le Bassin d'Argenteuil
1875
Pond at Argenteuil

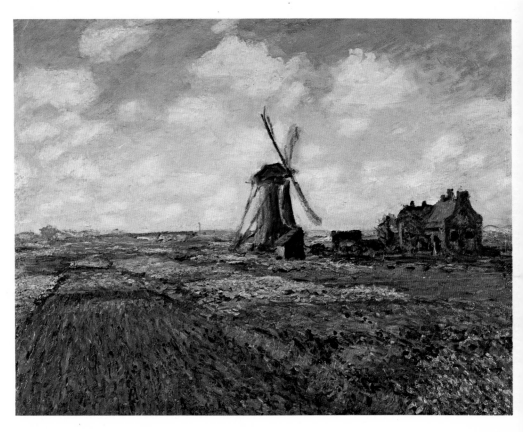

46
Champs de tulipes en Hollande
1886
A Field of Tulips in Holland

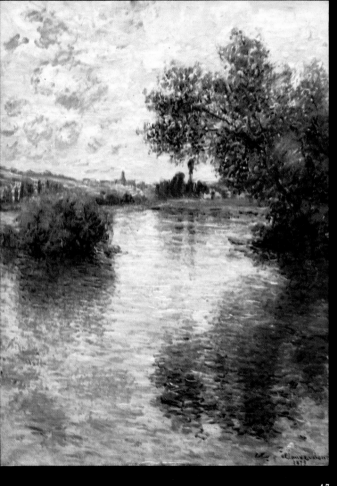

47
Paysage à Vétheuil
1879
Landscape at Vétheuil

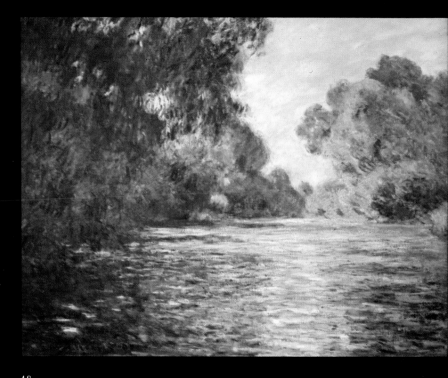

48
Bras de Seine près de Giverny
1897
The Banks of the Seine, near Giverny

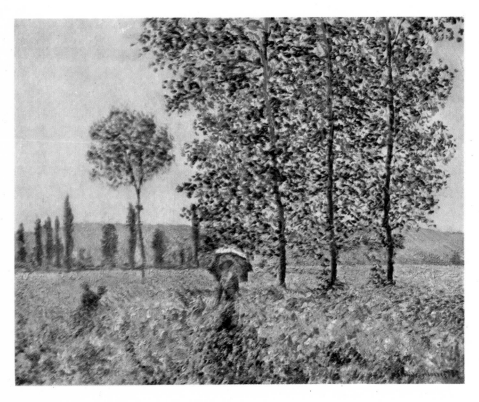

49 Champs au printemps. 1887. Field in Spring

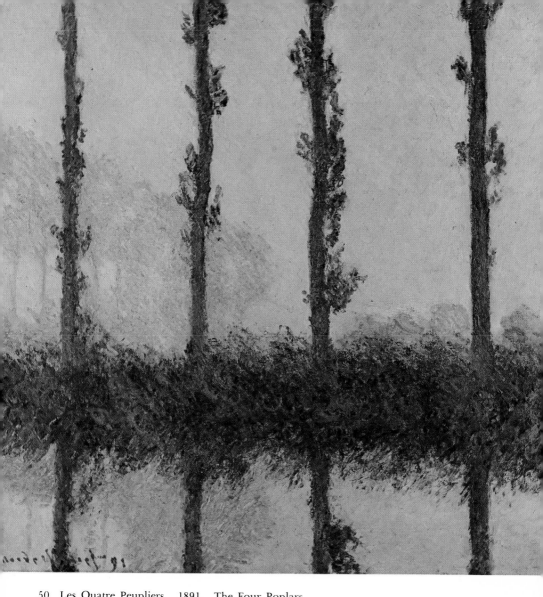

50 Les Quatre Peupliers. 1891. The Four Poplars

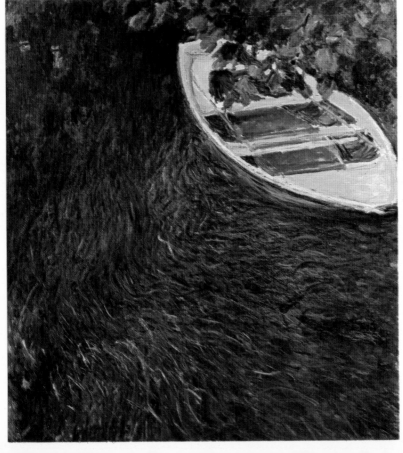

52
Canotage sur l'Epte
ca 1887
Boating on the Epte

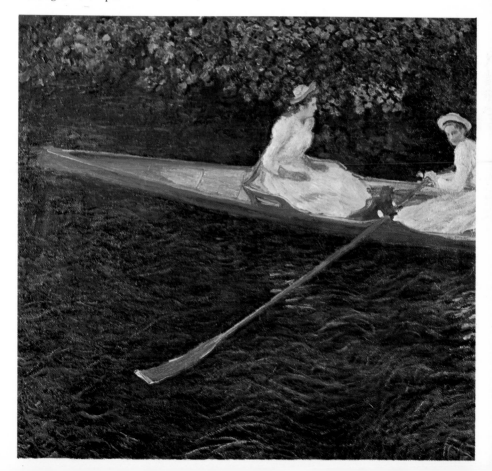

53
La Barque bleue
1887
The Blue Boat

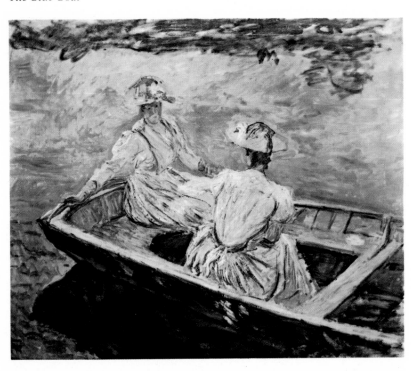

54
La Barque à Giverny
ca 1887
The Boat at Giverny

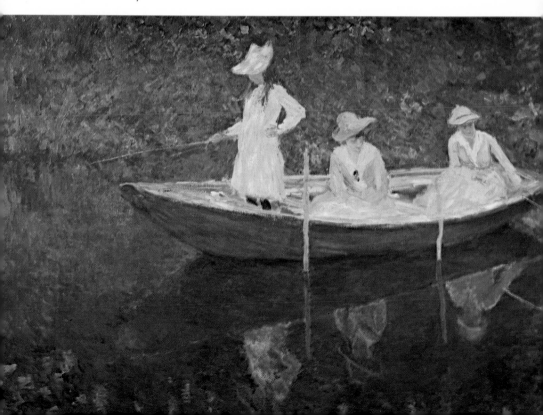

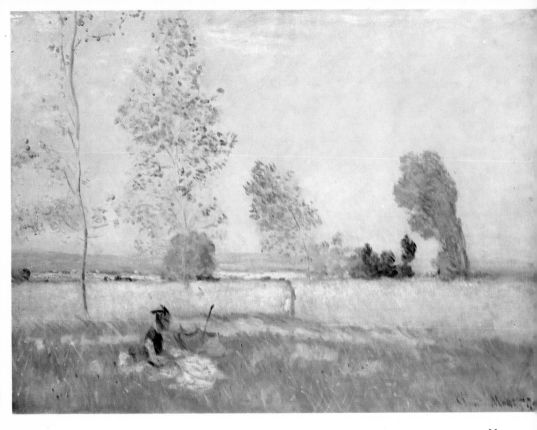

55
L'Eté
1874
Summer

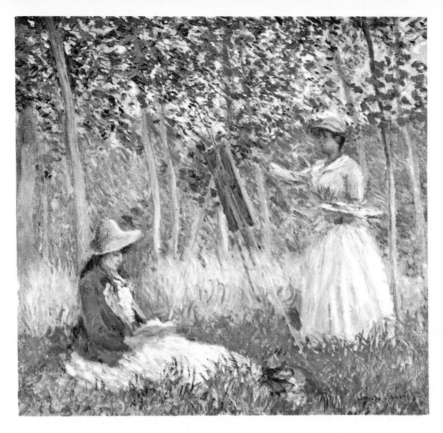

56
La Fille de l'artiste en train de peindre dans un paysage
1885
The Artist's Daughter painting in a Landscape

57
Madame Monet assise sous un saule (détail)
1880
Madame Monet under the Willows (detail)

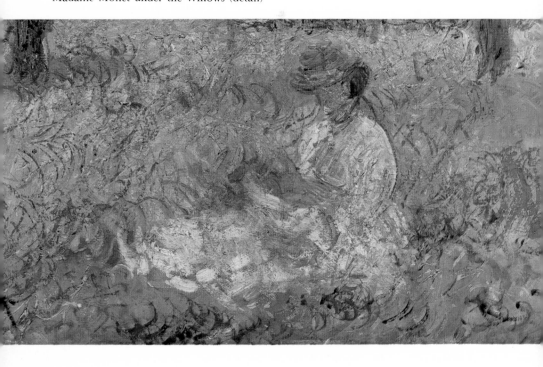

58
La Fille de l'artiste en train de peindre dans un paysage (détail)
1885
The Artist's Daughter painting in a Landscape (detail)

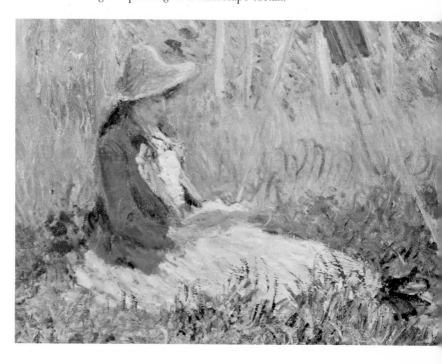

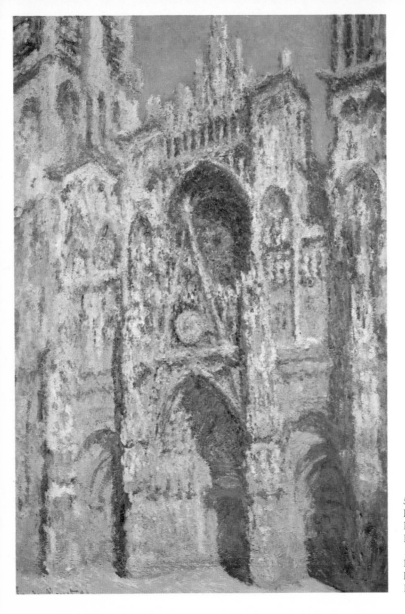

59
La Cathédrale de Rouen
Plein soleil
Harmonie bleue et or
1894
Rouen Cathedral
Bright Sunshine
Harmony in Blue and Gol

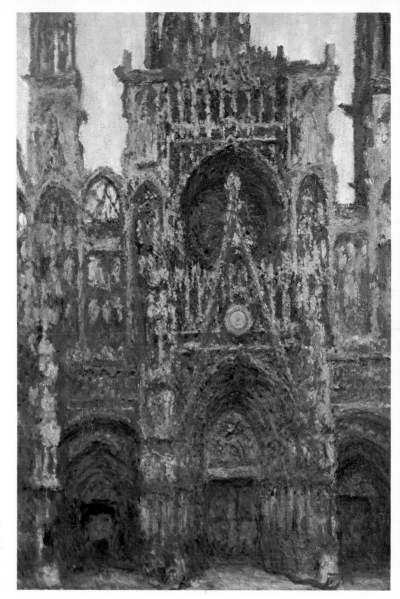

60
La Cathédrale de Rouen
Harmonie brune
1894
Rouen Cathedral
Harmony in Brown

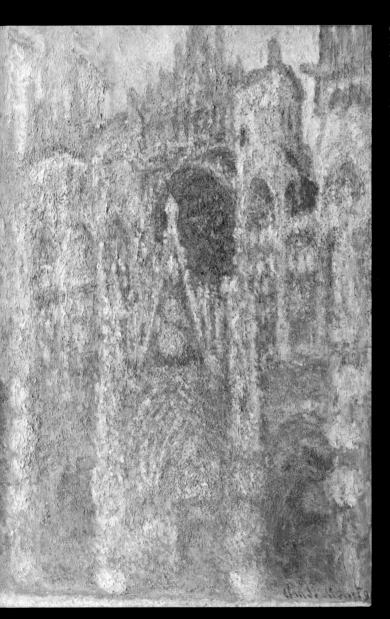

61
La Cathédrale de Rouen
Soleil matinal
Harmonie bleue
1894
Rouen Cathedral
Morning Sunshine
Harmony in Blue

62
La Cathédrale de Rouen
Temps gris
1894
Rouen Cathedral
Grey Mists

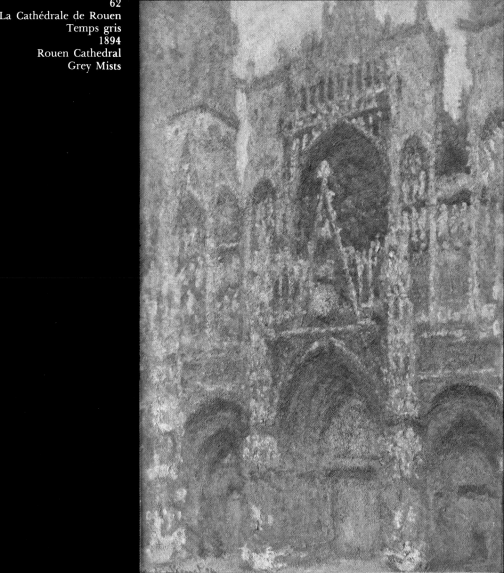

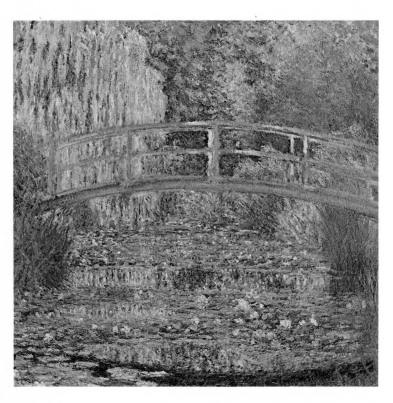

63
Le Bassin aux nymphéas. Harmonie verte
1899
Water-lily Pond. Harmony in Green

64
Le Bassin aux nymphéas
1899
Water-lily Pond

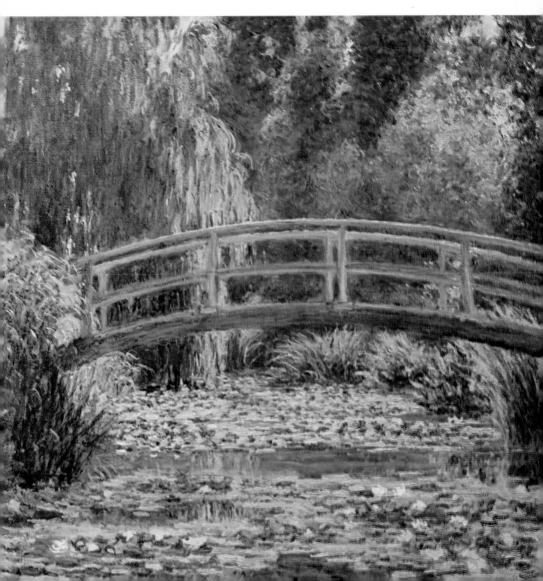

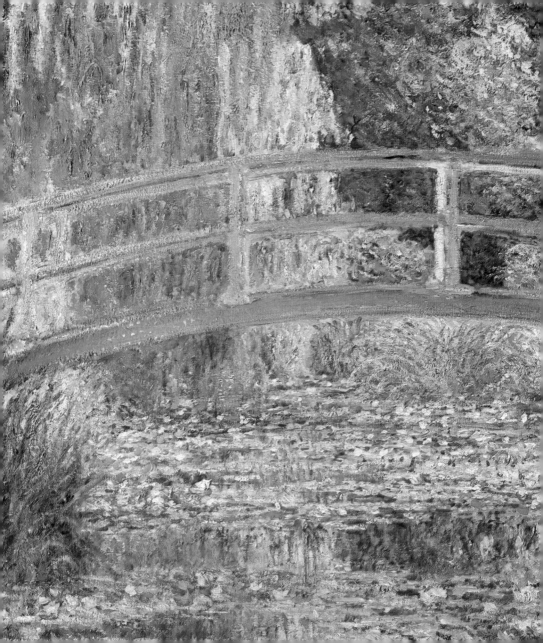

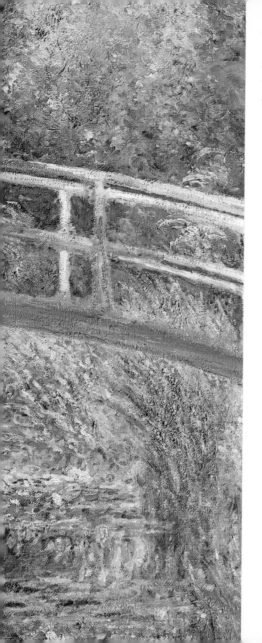

65
Le Bassin aux nymphéas (détail)
1899
Water-lily Pond (detail)

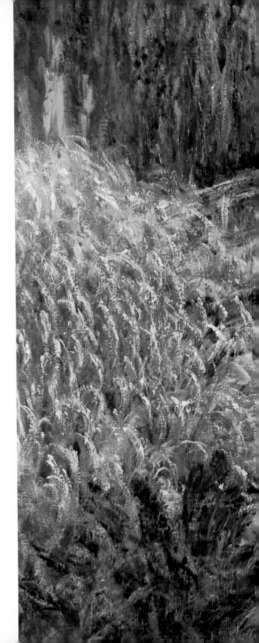

66
Le Bassin aux nymphéas. Harmonie rose (détail)
1900
Water-lily Pond. Harmony in Pink (detail)

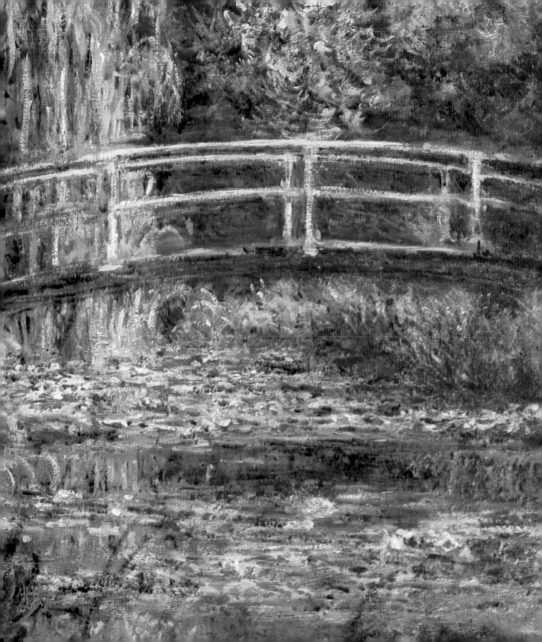

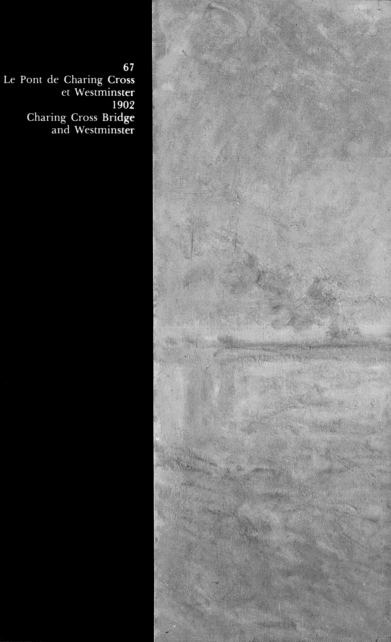

67
Le Pont de Charing Cross
et Westminster
1902
Charing Cross Bridge
and Westminster

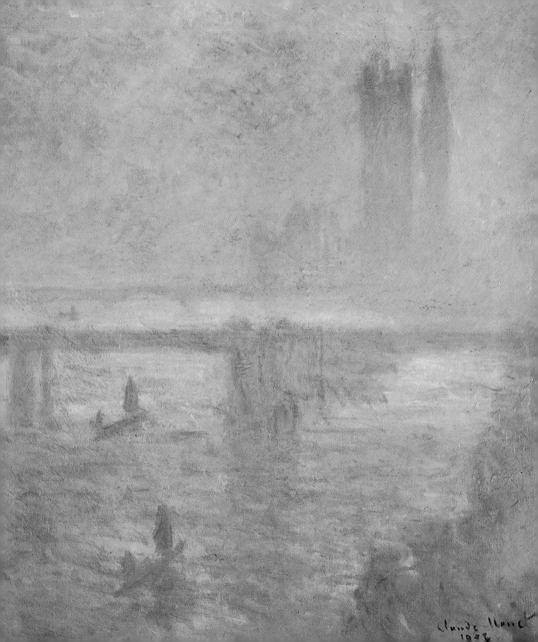

68
Londres. Le Parlement
1904
London. The Houses of Parliament

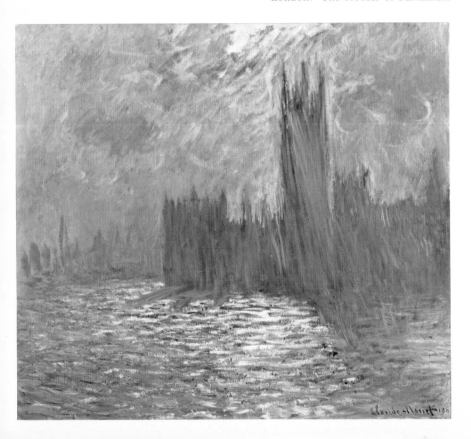

69
Londres. Le Parlement
1904
London. The Houses of Parliament

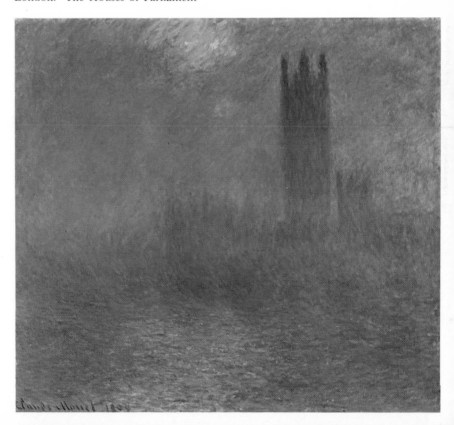

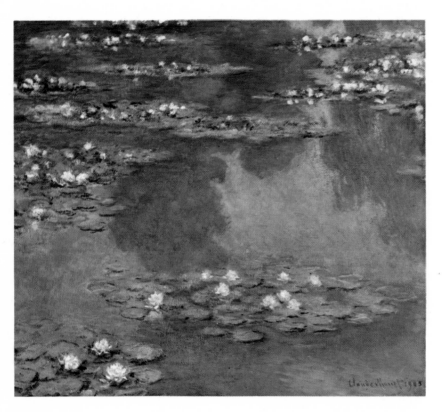

70
Nymphéas, paysage d'eau
1905
Water-lily, Waterscape

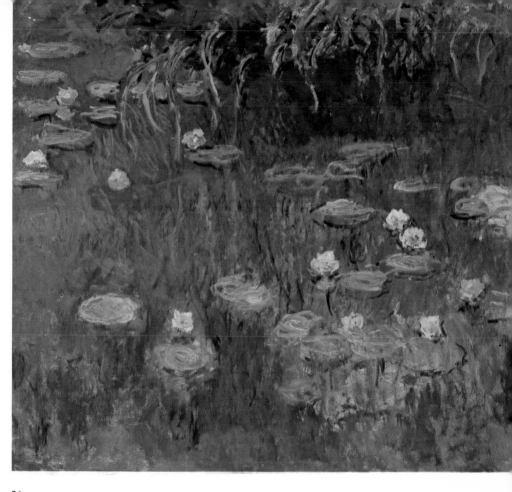

71
Nymphéas
ca 1916-1922
Water-lily

72

Le Grand Canal à Venise
1908
Venice. The Grand Canal

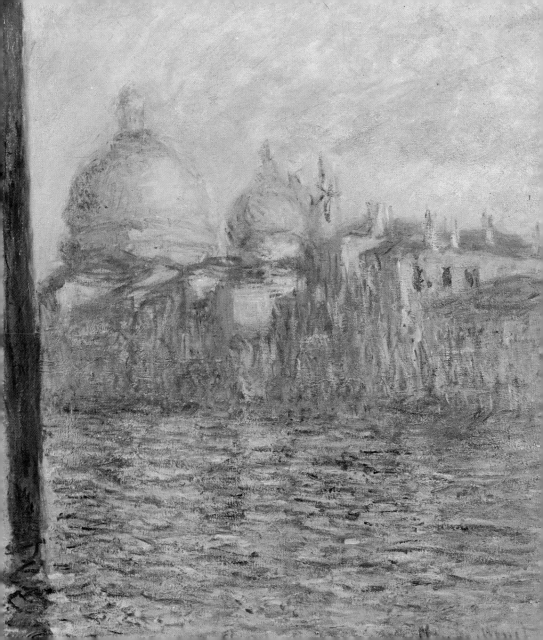

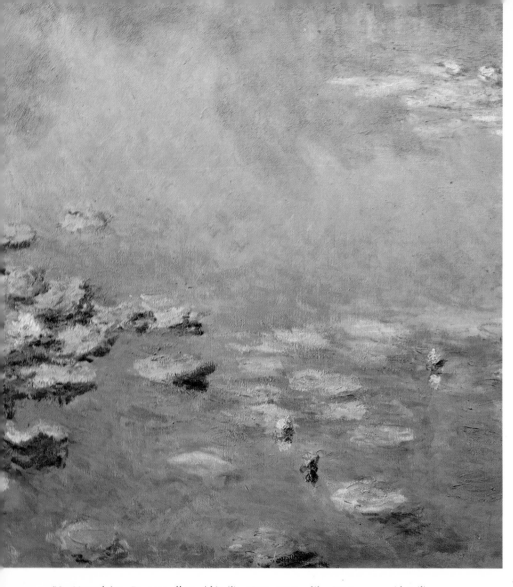

73 Nymphéas. Paysage d'eau (détail) 1906 Water-lily. Waterscape (detail)

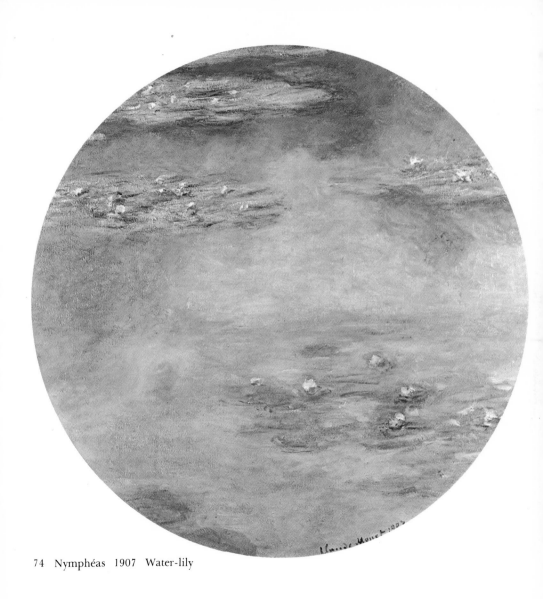

74 Nymphéas 1907 Water-lily

75
Nymphéas
ca 1918-1921
Water-lily

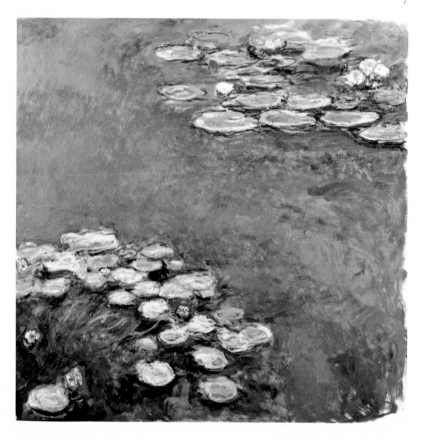

76
Nymphéas. Paysage d'eau
1908
Water-lily. Waterscape

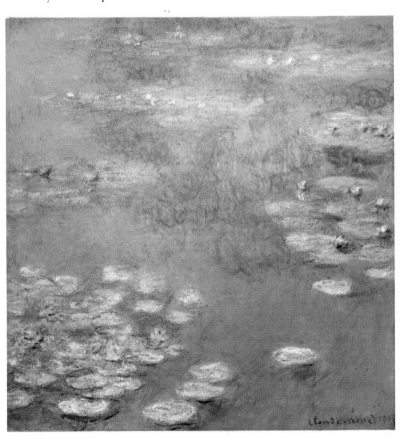

77
Les Nymphéas. Paysage d'eau (détail)
1904
Water-lily. Waterscape (detail)

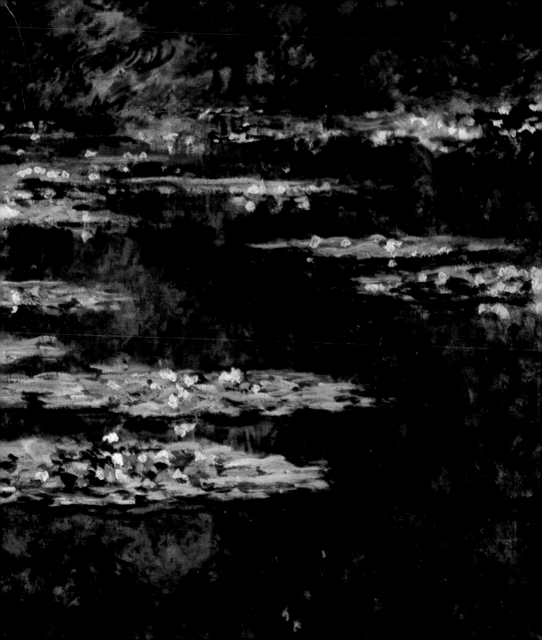

78
Nymphéas. Paysage d'eau (détail)
1908
Water-lily. Waterscape (detail)

Claude Monet 1908

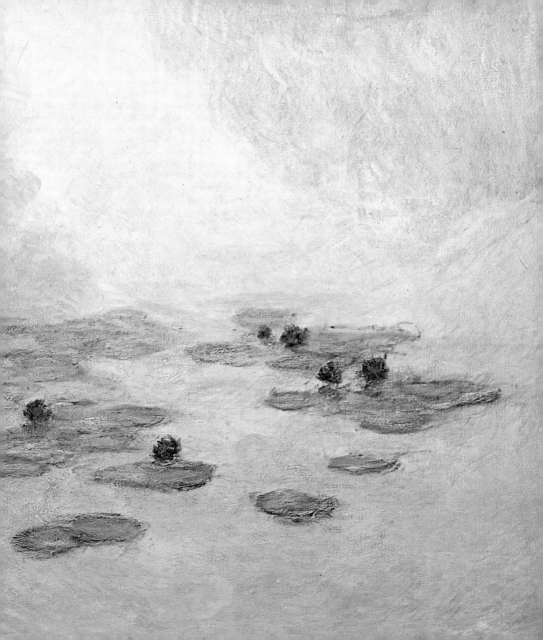

Nymphéas (les nuages roses)
ca 1916-1923
Water-lily (Pink Clouds)

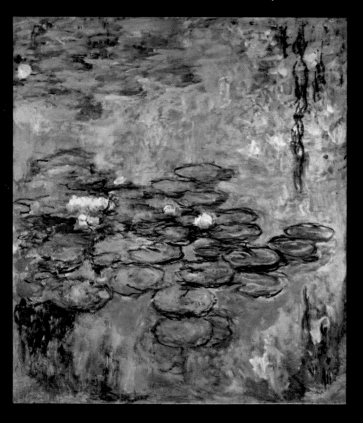

80
Le Bassin aux nymphéas, Giverny
1919
Water-lily Pond, Giverny

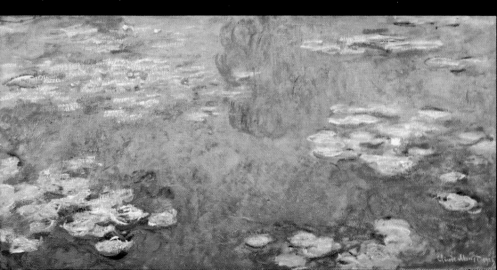

81
Le Saule pleureur
ca 1919
Weeping Willow

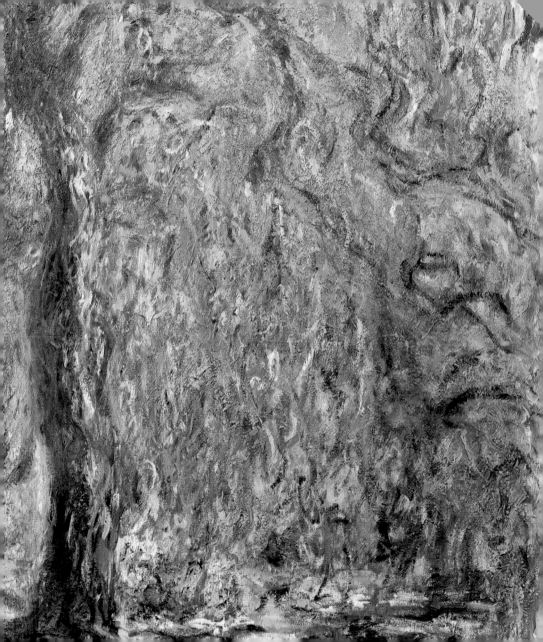